live. love. bark.

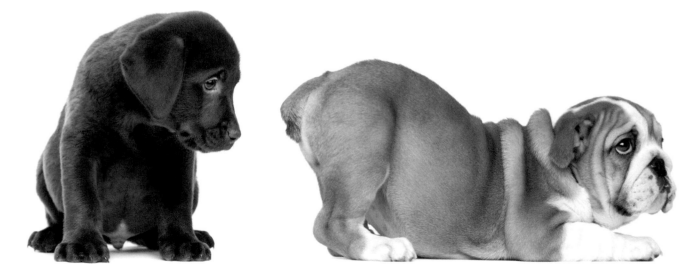

sourcebooks

Copyright © 2017 by Sourcebooks, Inc.
Cover and internal design © 2017 by Sourcebooks, Inc.
Cover and internal design by Allison Sundstrom/Sourcebooks
Cover and internal images © GlobalP/Thinkstock, Eric Isselee/Shutterstock

Sourcebooks and the colophon are registered trademarks of Sourcebooks, Inc.

Published by Sourcebooks, Inc.
P.O. Box 4410, Naperville, Illinois 60567-4410
(630) 961-3900
Fax: (630) 961-2168
www.sourcebooks.com

Printed and bound in China.
LEO 10 9 8 7 6 5 4 3 2 1

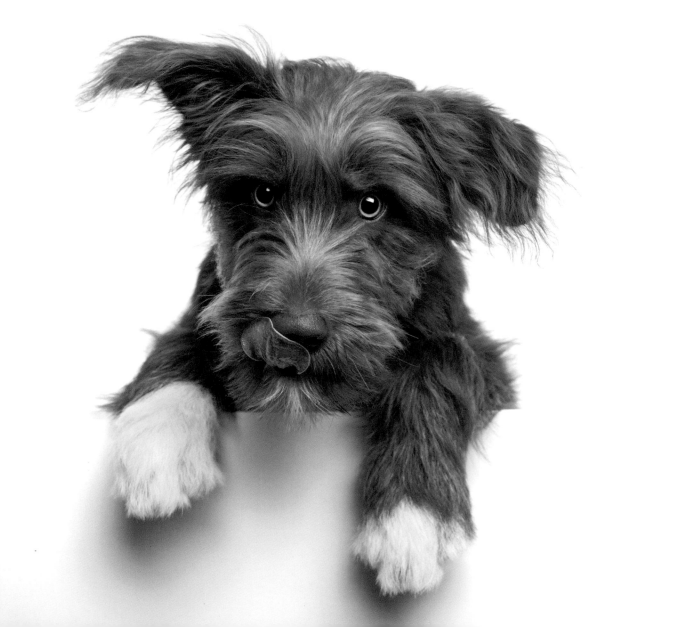

Where
you lead,

I will
follow...

—Carole King,
Gilmore Girls theme song

You can't just tell someone you love them—you have to *show it!*

What makes you *different* makes you *beautiful.*

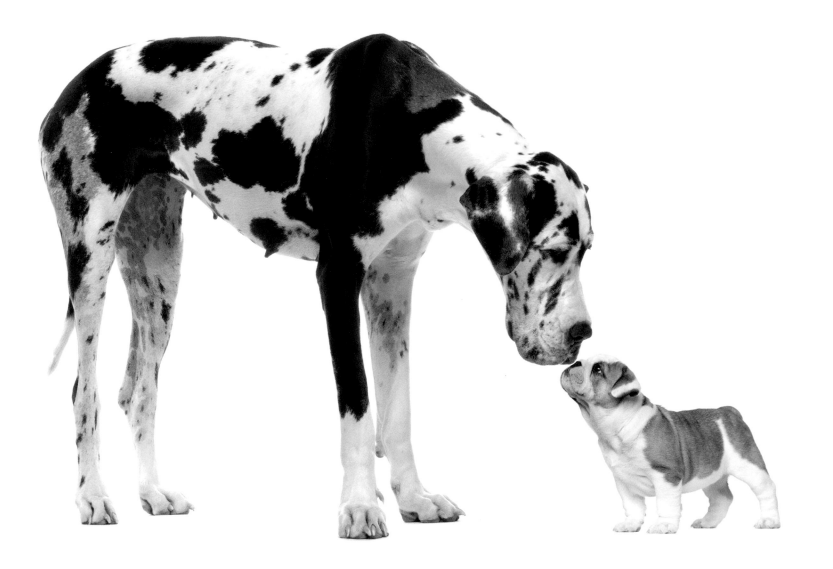

Enjoy the *little* things.

Why fit in

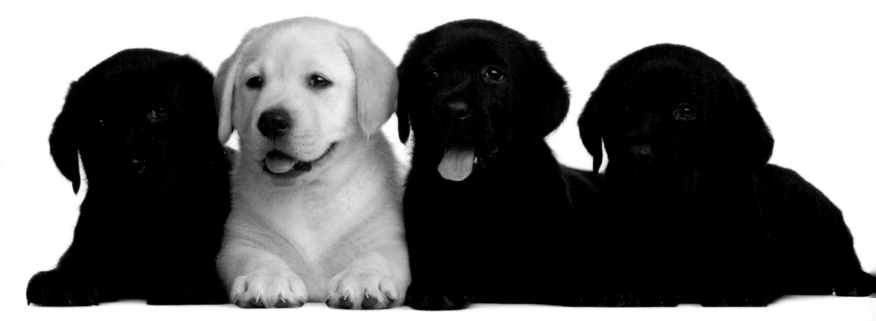

when you were born to **stand out?**

—Dr. Seuss

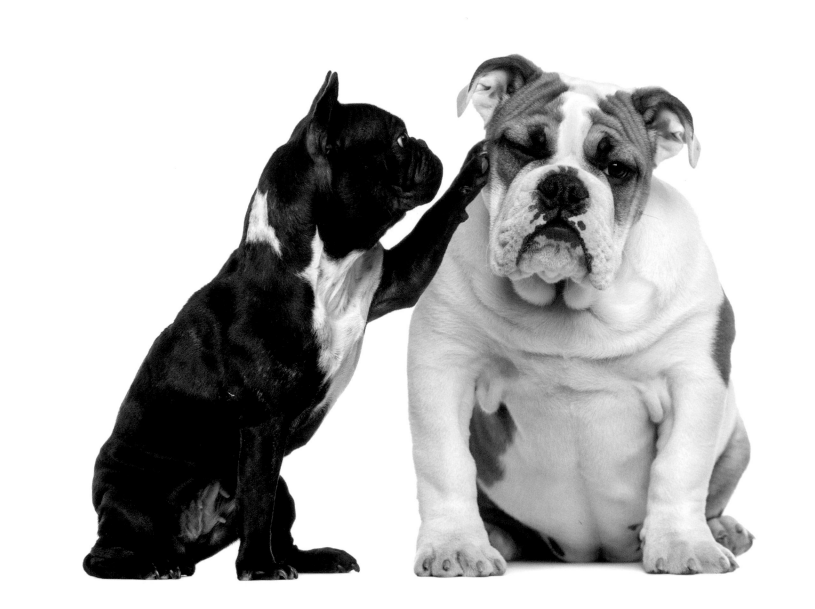

PATIENCE
is a virtue.

We should probably cuddle now.

Life isn't perfect, but your hair can be!

Reach out and make a

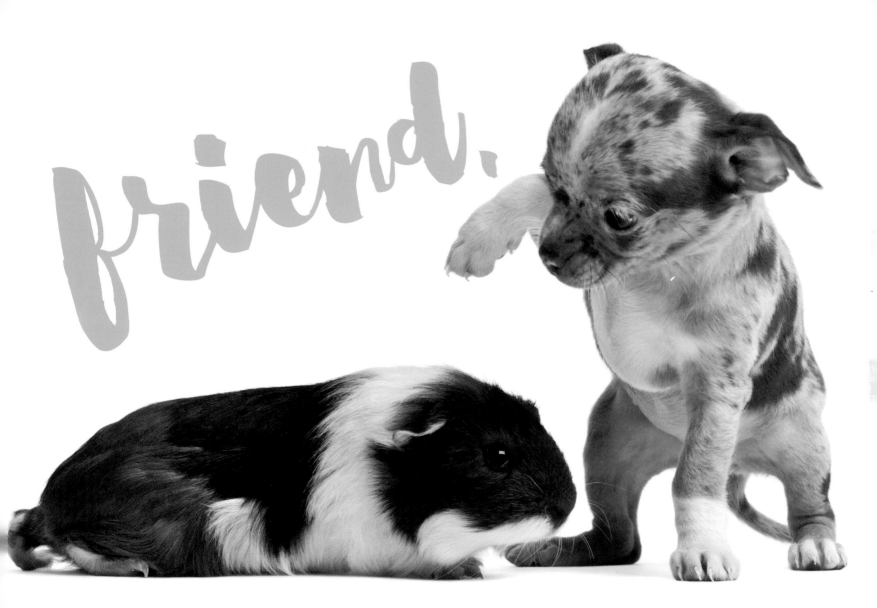

You never know until you try.

Strength can come in

small
packages.

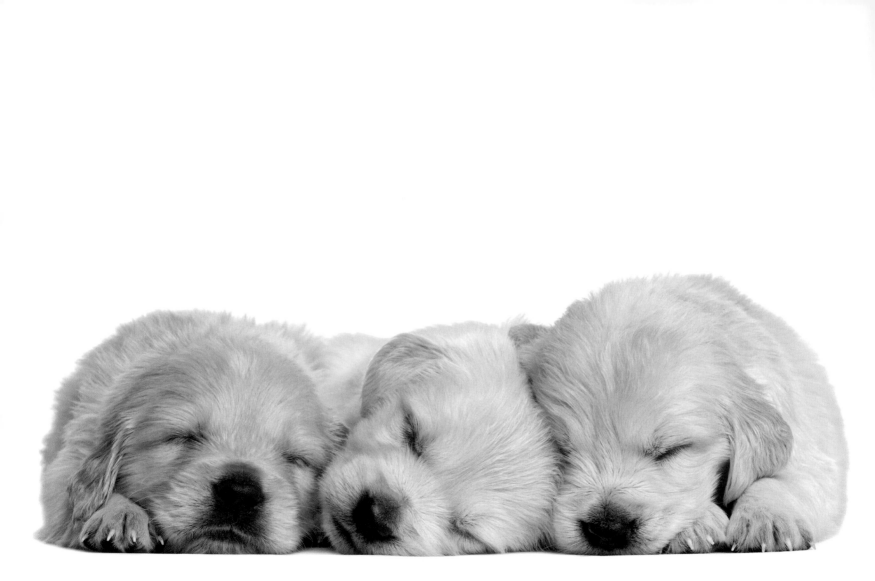

Sleep is the best meditation.

—Dalai Lama

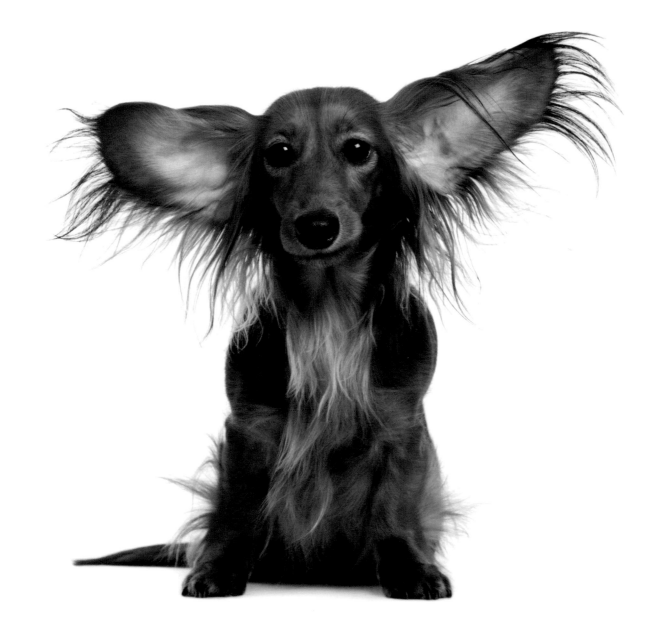

Friendship
isn't a big thing—
it's a
million tiny
things.

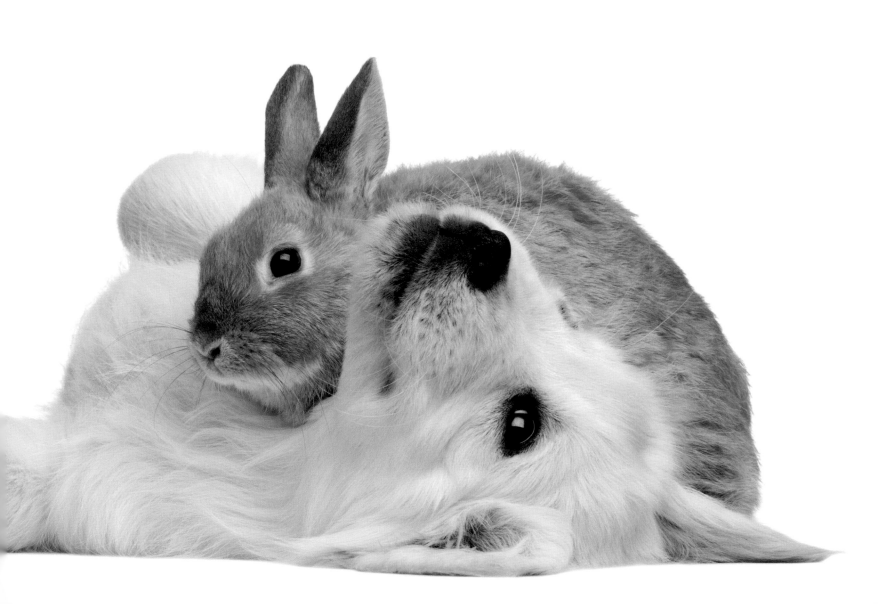

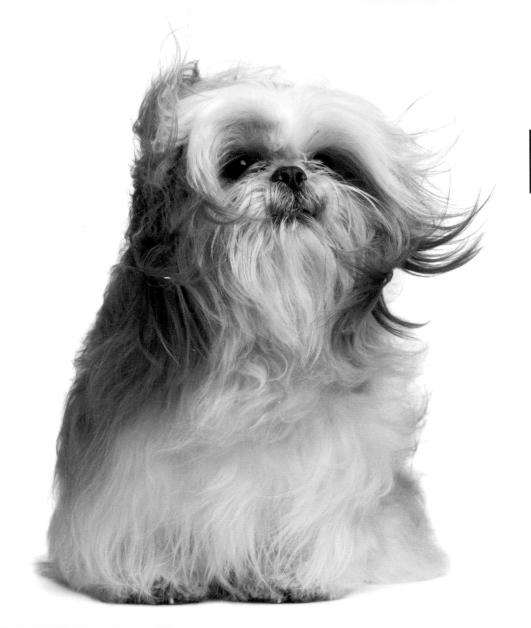

Let your
hair
down
and

Let people see the real, *imperfect*, flawed, quirky, **weird**, beautiful, *magical* *person* that you are!

JOY
is not
in things.

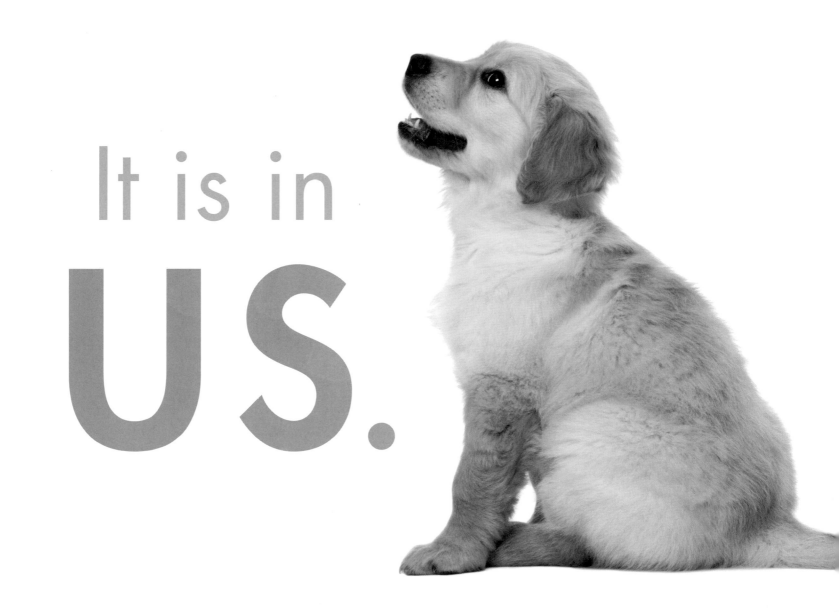

It is in
US.

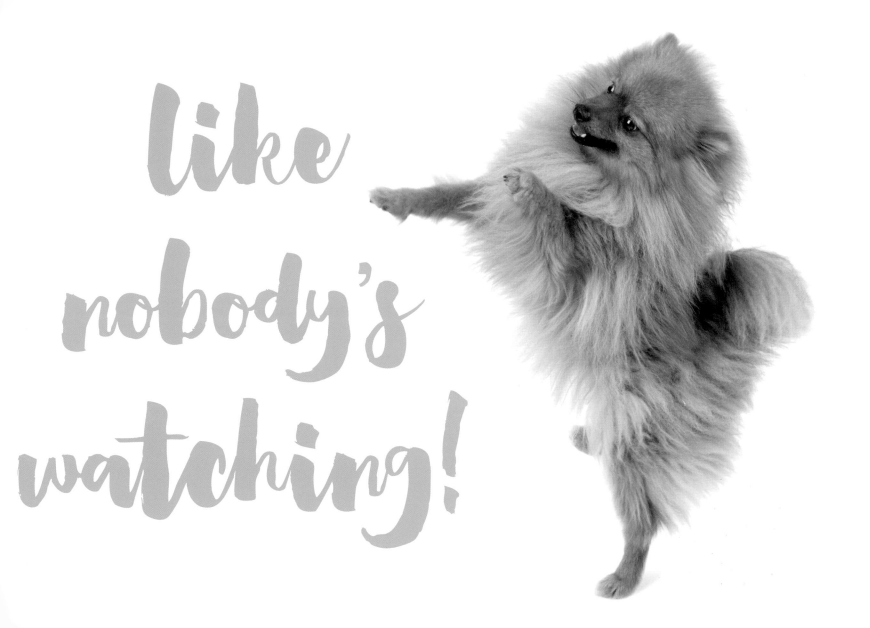

like nobody's watching!

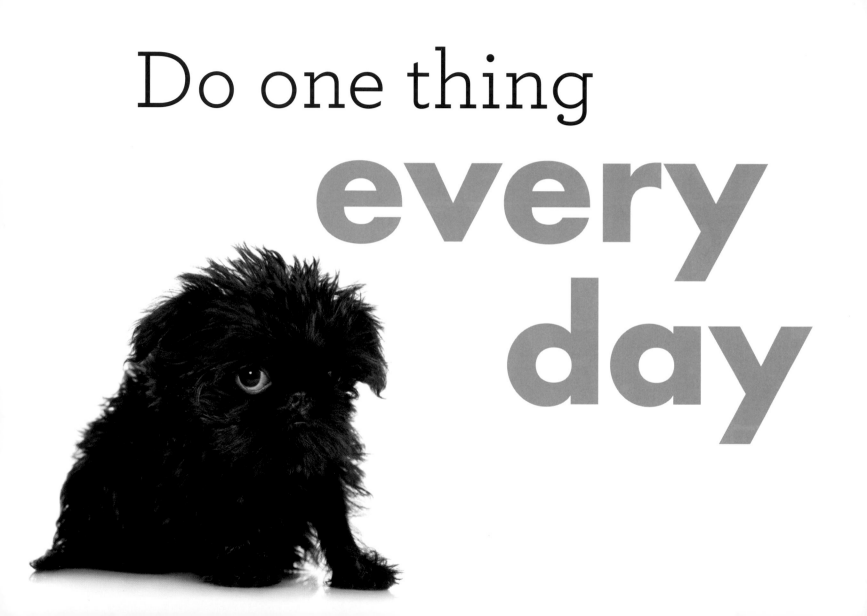

that **scares** you.

Take time
to make your
soul happy.

We are dreamers

OF DREAMS.
— Arthur O'Shaugnessy

All things are possible

WITH

PERSISTENCE.

To find yourself,
you must look
within yourself
and not others.

—Damian Stafton

Pull yourself *together!*

is the prettiest thing you can wear.

If you haven't found it yet, **keep looking.**

—Steve Jobs

Face challenges HEAD ON.

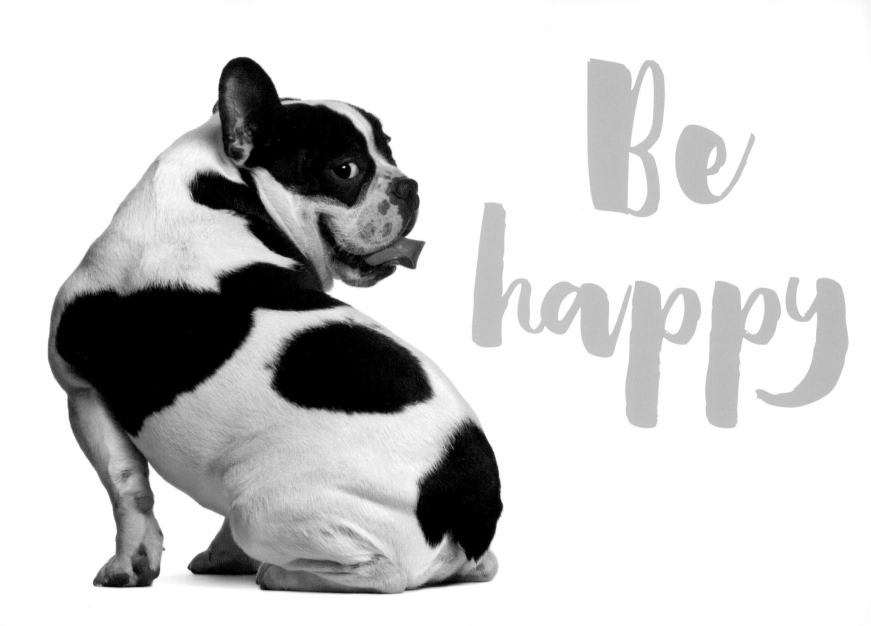

Be happy

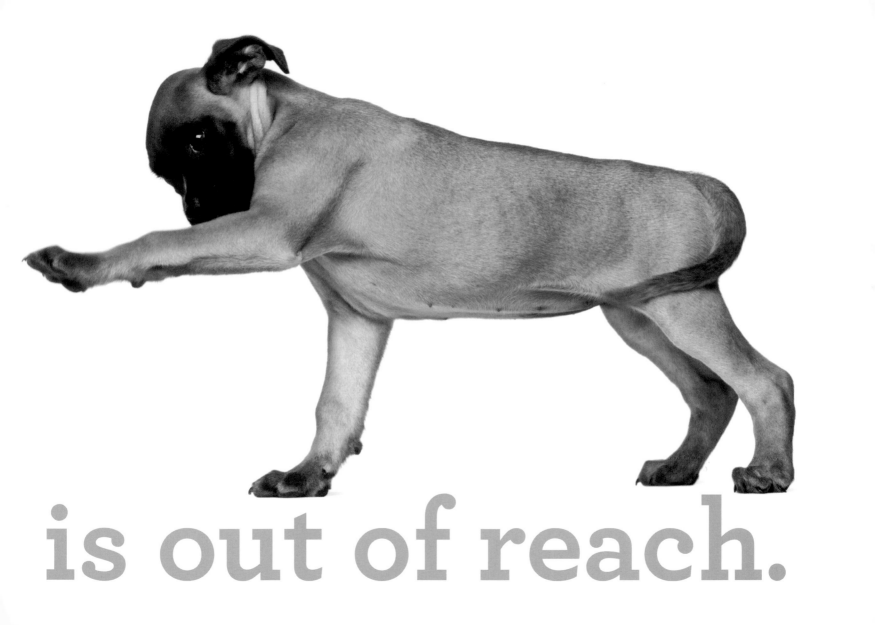

is out of reach.

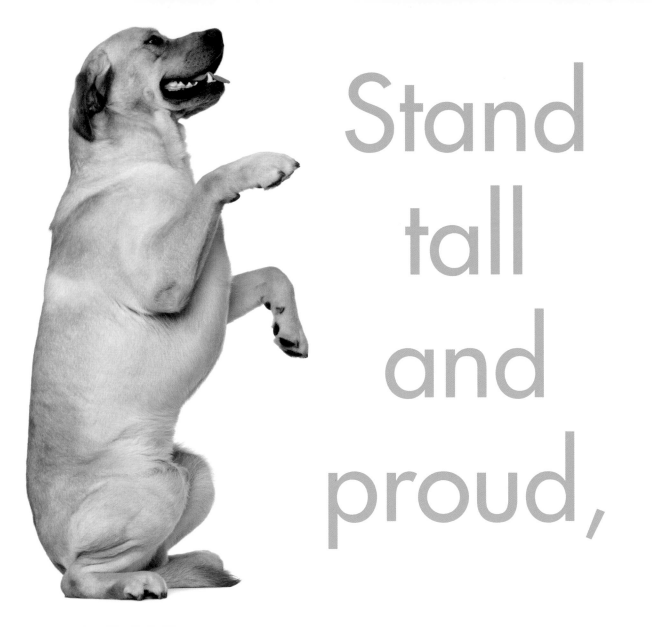

Stand
tall
and
proud,

You gotta look for the good in the bad,

the **happy** in your sad,
the **gain** in your pain,
and what makes you
grateful not hateful.

—Karen Salmansohn

It never hurts to keep looking

for sunshine.

—Eeyore, *Winnie-the-Pooh*

Sometimes
I pretend to
be normal...

but it's
more fun
being me.

Come here and let me *kiss you.*

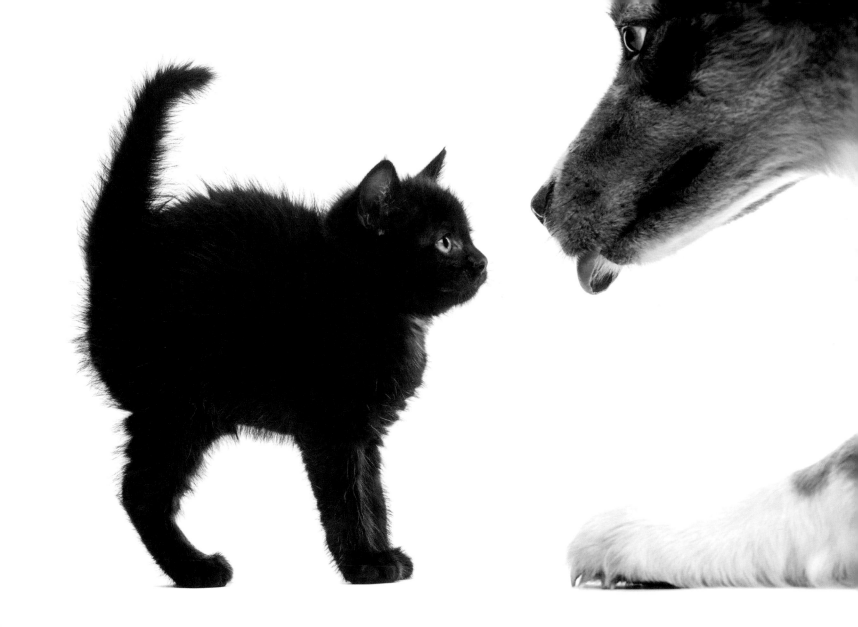

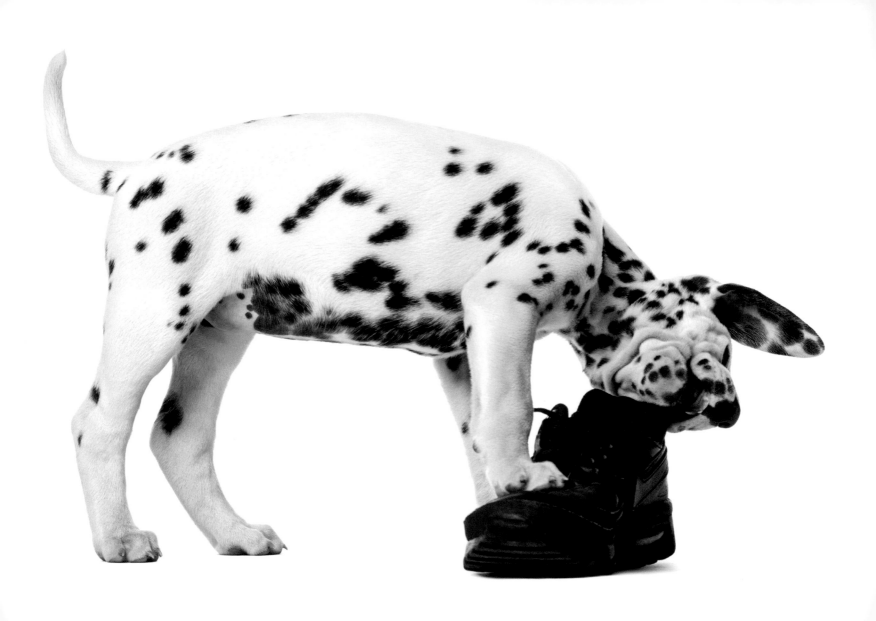

Savor the small things in life.

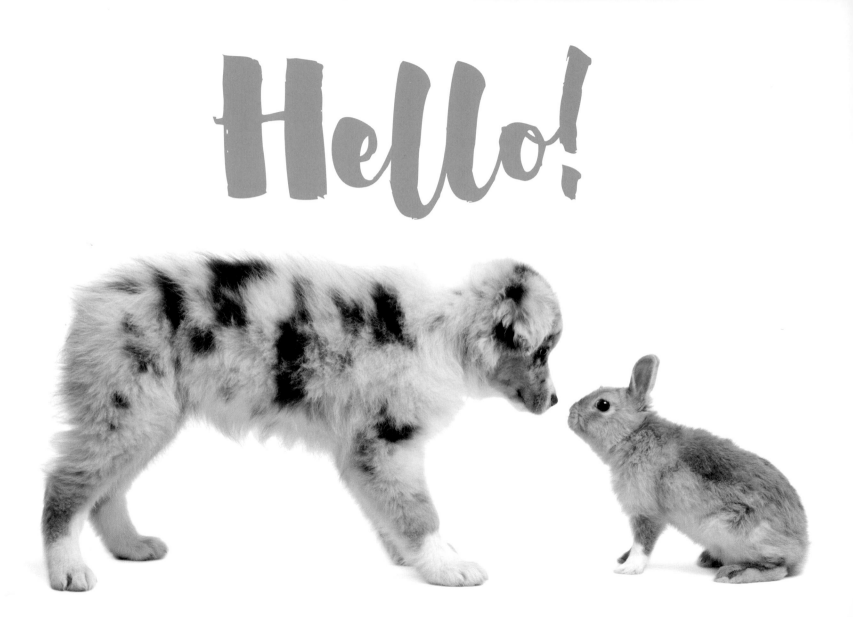

Want to be best friends?

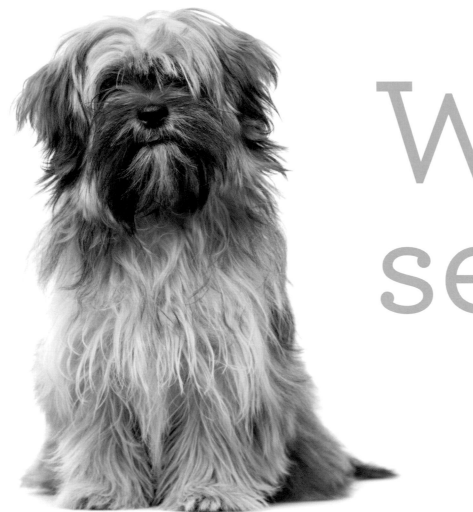

We see

what we
want
to *see.*

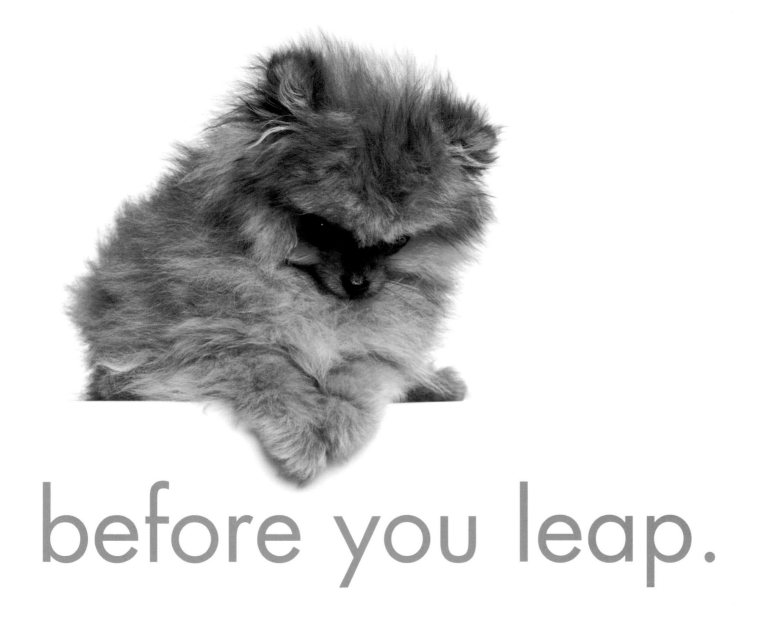

before you leap.

Look up at the stars, not down at your feet!

—Stephen Hawking

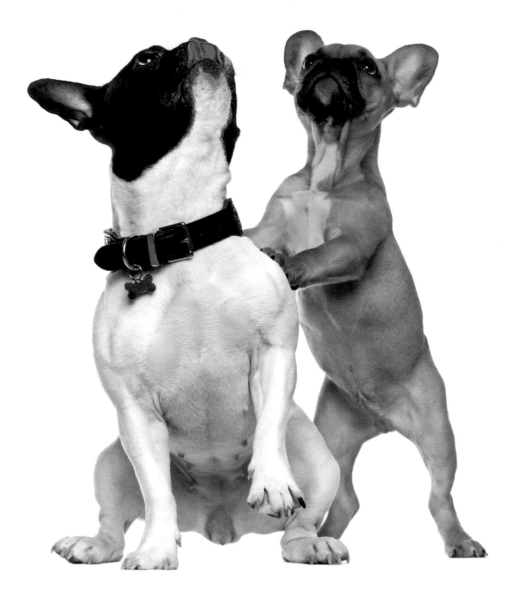

The best friendships are

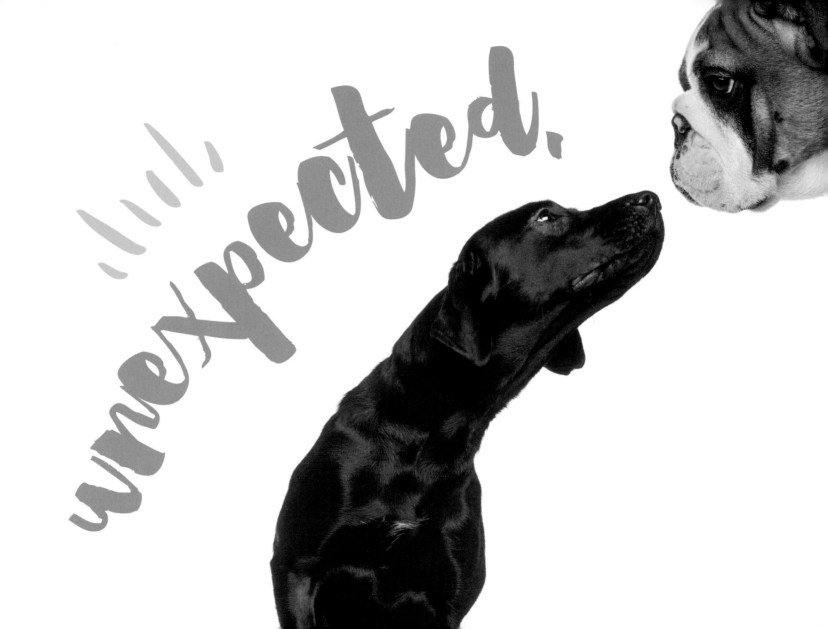

unexpected.

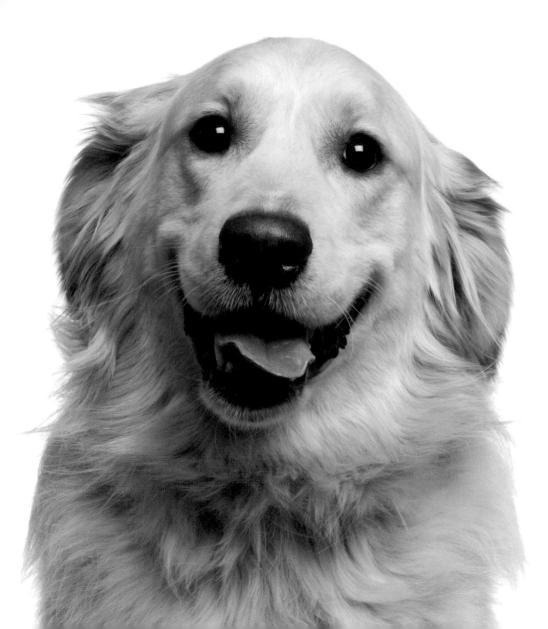

goes a
long
way.

—Quentin Tarantino

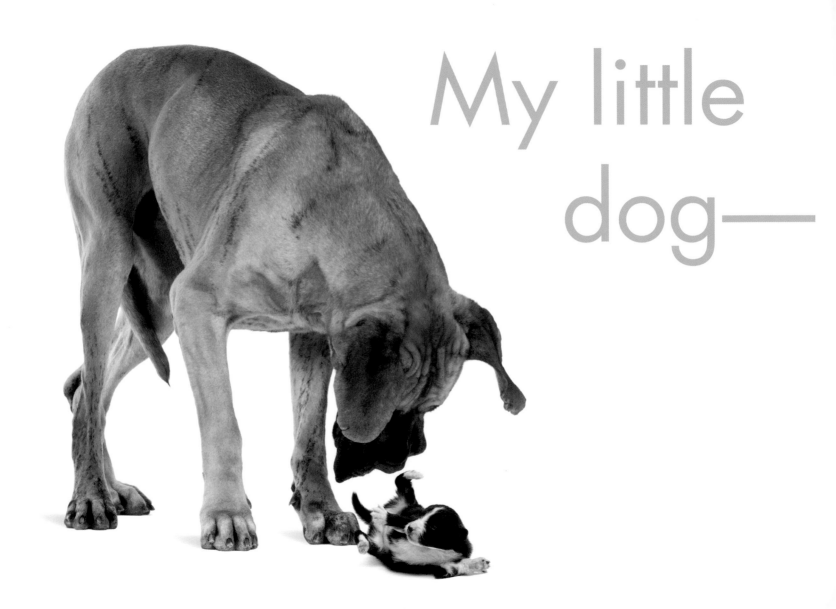

My little
dog—

a **heartbeat**
at my feet.

—Edith Wharton

Happiness is
a warm puppy.

—Charles M. Schulz

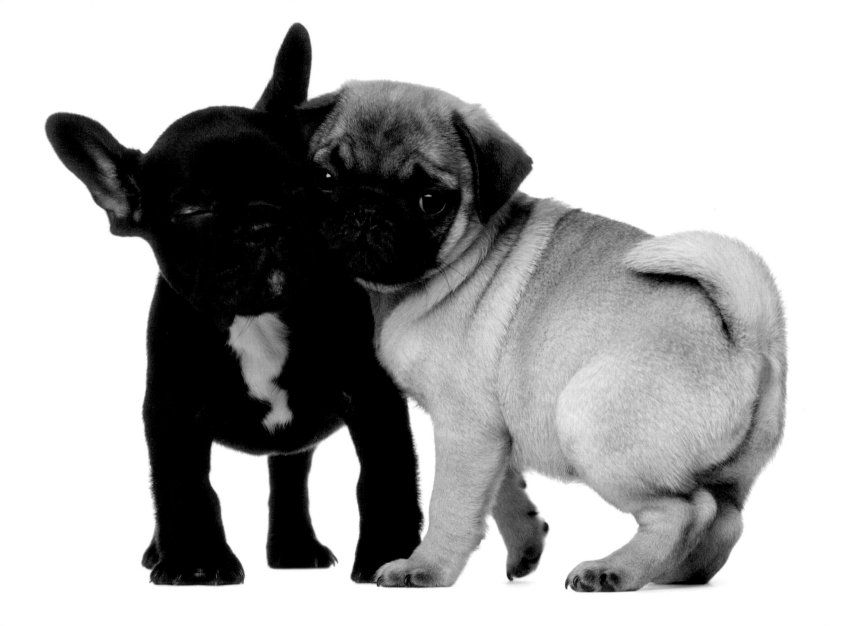

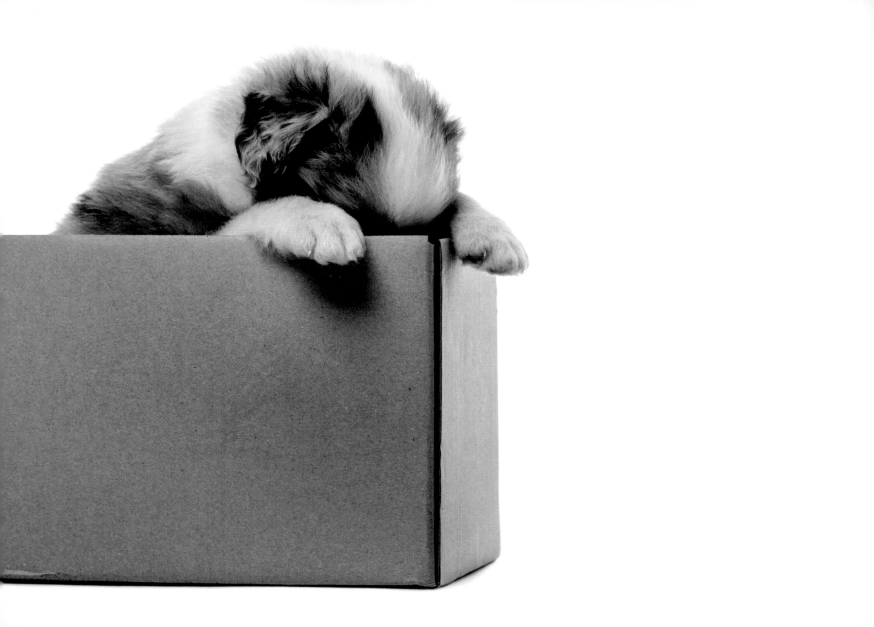

Life is what happens outside your comfort zone.

It's the *friends* we meet along the way that help us *appreciate* the journey.

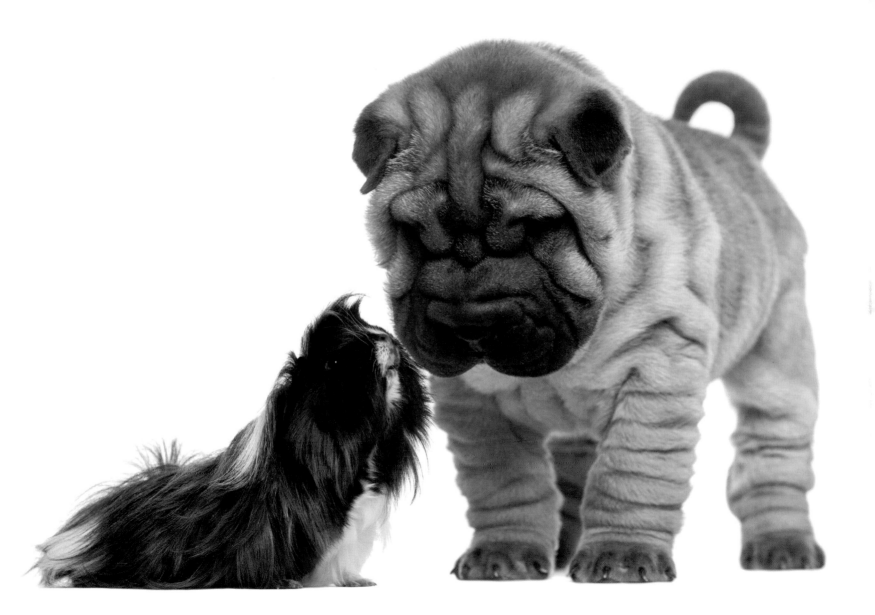

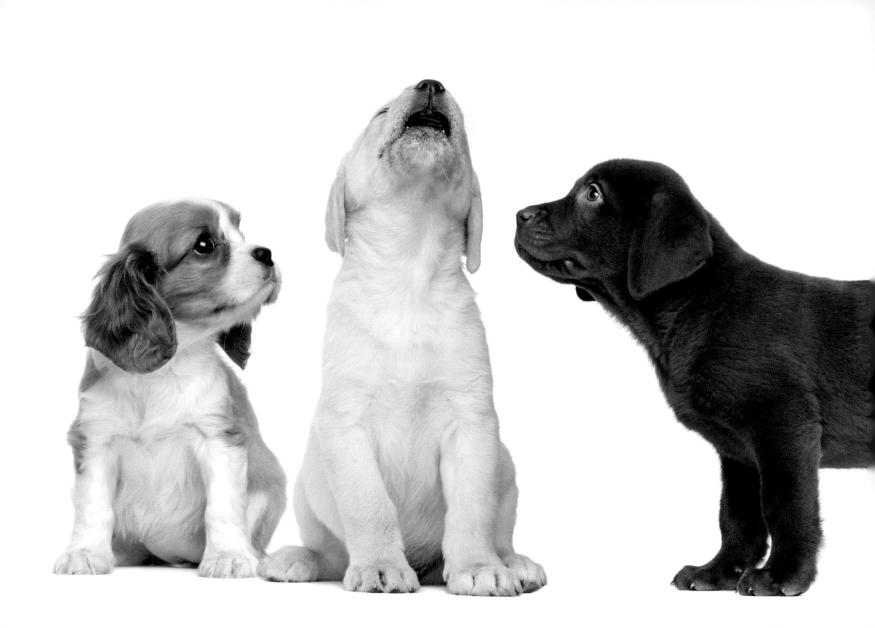

Life is a song—

sing it!

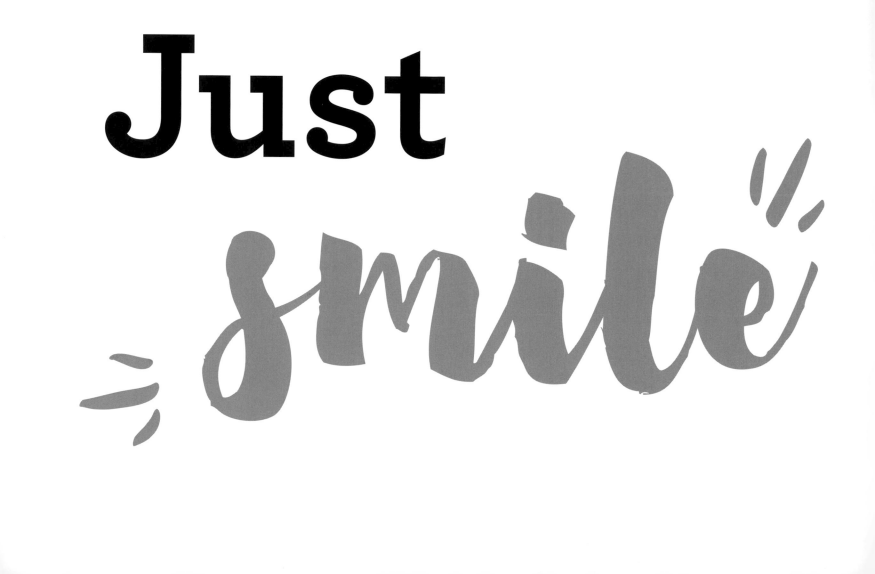

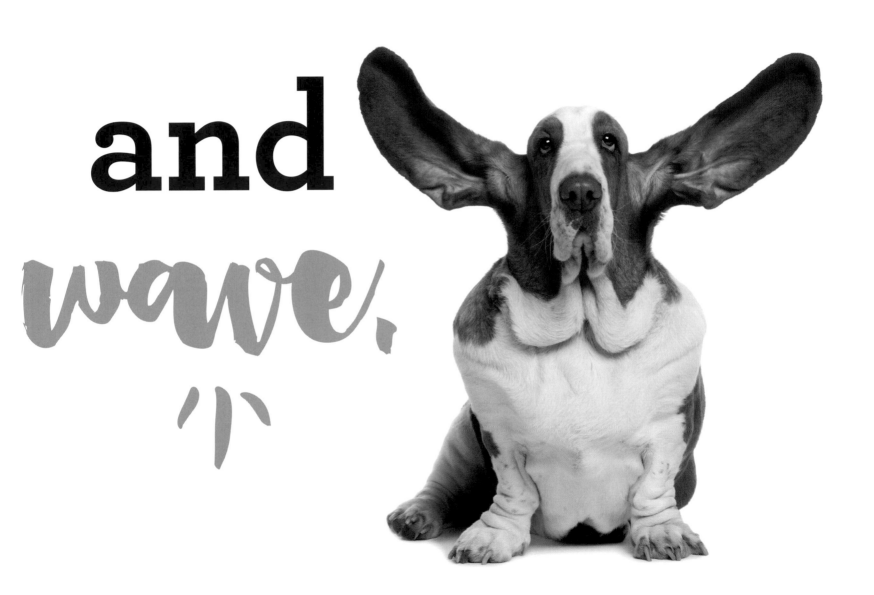

and wave.